The Standard of Ur
Sarah Collins

The British Museum

© 2015 The Trustees of
the British Museum

First published in 2015 by
The British Museum Press
A division of the British Museum
Company Ltd
The British Museum
Great Russell Street
London WC1B 3DG

Reprinted 2024

A catalogue record for
this book is available
from the British Library

ISBN 9780714151137

Designed by Bobby Birchall,
Bobby and Co.

Printed and bound in China by
1010 Printing International Ltd

The papers used in this book are
recyclable products and
the manufacturing processes are
expected to conform to
the environmental regulations of
the country of origin.

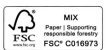

Contents

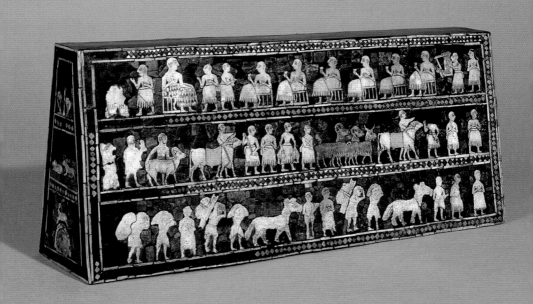

Introduction

The Standard is a remarkable work of ancient narrative art. It is a wooden box-like object of a shape described in geometry as a trapezoidal prism. It measures 21.7 cm in height and 50.4 cm in length with a width of 11.6 cm at the base and 5.6 cm at the top, which means that the sides slope inwards slightly towards the top. The two rectangular sides and the two truncated triangular ends consist of inlaid panels of imagery; the base and the top of the box are undecorated. The illustrated panels are made with engraved shell figures and mosaic tesserae of lapis lazuli, red limestone and shell. The rectangular sides depict scenes of a battle and of a banquet. These enduring artistic themes are illustrated more thoroughly and informatively on the Standard than on any other contemporary ancient object. About four and a half thousand years ago, around 2500 BC, the Standard was buried in a tomb in the city of Ur, located in the region known as Sumer in ancient Mesopotamia. Its original function is still unknown but since its excavation in 1928 it has become one of the most famous ancient Mesopotamian objects to have been discovered.

The name Mesopotamia comes from the ancient Greek description 'between the rivers'. This originally referred to the land located between the two great rivers, the Tigris and Euphrates, which flow from highland Turkey down to the Gulf through modern Iraq. However, it came to be used in a much broader sense to refer also to the territories adjoining the two rivers, including parts of Syria and Turkey (see fig. 2). By 3000 BC Mesopotamian civilisation had fully emerged, with large cities and complex administrative, economic and religious organisations. The world's earliest writing, dating to around 3300 BC, is found on clay tablets discovered in the city of Uruk in southern Mesopotamia (now southern Iraq). A cut reed pressed into moist clay produced the wedge-shaped impressions that give the writing its modern name, cuneiform, from the Latin *cuneus*, meaning 'wedge'. The cuneiform tablets that have been excavated are astonishingly informative but there is a great deal that is yet to be revealed. In particular, the chronology of Mesopotamia for the third

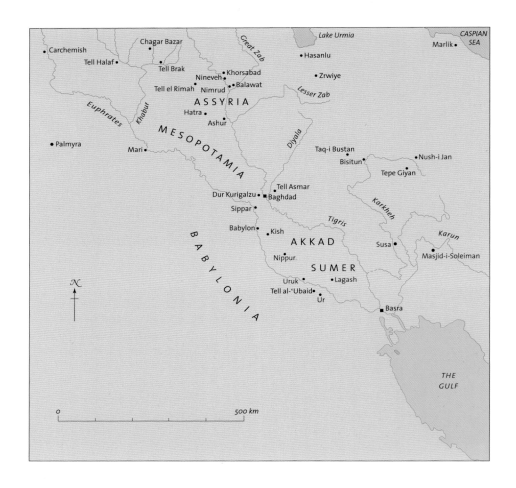

2. Ancient cities of the Middle East.

millennium BC is not certain and the dates of events during this time are not precisely known. Different chronologies have been proposed based on archaeological, scientific and astronomical evidence and therefore the published dates for the Standard currently vary from 2600 to 2400 BC.

During the third millennium BC two regions were distinguished by the inhabitants of southern Mesopotamia – Sumer, in the extreme south, and Akkad, in the northern part of the Tigris and Euphrates flood plain. Two different languages were spoken: Sumerian, unrelated to any other known language, and Akkadian, which belongs to the

Semitic family of languages along with Arabic and Hebrew. By 2600 BC, southern Mesopotamia was divided into many city-states. A city-state consisted of the city together with the surrounding towns and villages that supplied it with produce. Boundary disputes between the city-states often led to conflict or even war. Conquests and alliances would result in the king of one city-state claiming rule over a wider area and gaining more prominence for his city. However, despite linguistic and political differences, southern Mesopotamia was culturally united, with shared beliefs and artistic traditions.

The discovery of the Standard

One of the world's first cities, ancient Ur (modern Tell al-Muqayyar), in southern Mesopotamia was inhabited from as early as 6000 BC until the fourth century BC. Its strategic location near the head of the Gulf meant that it was well situated to control much of the developing seaborne trade and during the third millennium BC it became highly important both economically and politically. At various times, the kings of Ur ruled not only the city itself but also the surrounding city-states. Ur was also an important religious centre and by 2000 BC the city skyline was dominated by an immense ziggurat (stepped temple tower) dedicated to the moon god.

Between 1922 and 1934 the archaeologist C. Leonard Woolley directed twelve seasons of excavations at Ur on behalf of the British Museum and the University of Pennsylvania Museum in Philadelphia. Under the Iraq Antiquities Law of the time, a representative share of the excavation finds of each season was allocated to these two museums. The excavations were the most extensive ever undertaken in Iraq at the time, continuing for several months each year and usually employing between 200 and 300 workmen. Vast areas of the city were revealed including houses, public buildings and temples, from a range of time periods. Woolley's achievements were extraordinary and the excavations have contributed hugely to our knowledge about ancient Mesopotamia.

The Royal Tombs of Ur

The most spectacular discoveries at Ur were made within a cemetery of the Early Dynastic III period (*c.*2600–2300 BC) that Woolley named 'The Royal Cemetery'. Here, among hundreds of more modest burials, were sixteen graves that he distinguished as 'Royal Tombs' because of their construction, abundance of grave goods and evidence of elaborate burial rituals and human sacrifice.

The Royal Tombs probably represent a time span of about a century around 2500 BC. They varied in their construction but in general they consisted of a stone or brick tomb built at the bottom of a vertical shaft dug several metres down through the earth. A ramp provided access to the tomb and sometimes there was also an open space or pit dug outside it. The bodies of guards or soldiers lay near the access ramp, as if guarding the entrance to the tomb. The most important occupant lay within a tomb chamber, sometimes with a few attendants. Outside the tomb in the pit, now usually referred to as the 'death

pit', were the bodies of many more attendants including musicians, and in some cases there were also oxen with wheeled vehicles. The largest pit, named by Woolley the 'Great Death Pit', included 68 women arranged in rows. All of the women and some of the men within the Royal Tombs wore highly decorative jewellery and large quantities of extraordinarily rich grave goods were buried with them. The wide variety of exotic materials buried in these tombs and in the Royal Cemetery in general, demonstrates the trading activities and great wealth of the city of Ur at this time.

The Royal Tombs represent a very extravagant version of the Sumerian practice of burial with personal possessions, provisions for the afterlife and gifts for the gods. Woolley believed they were for the kings and queens of Ur and that their servants willingly died with them in a ritual of human sacrifice in order to continue their service in the afterlife. The method of death of the attendants and the details of the burial rituals at Ur for the most part still remain a mystery. In addition, very few objects found in the Royal Cemetery are inscribed, and those that are do not name a Sumerian king or queen currently known from cuneiform texts, nor do they specify that the person named is royal. However, we do know that the name of the main occupant of one of the tombs was Puabi, and that she was a queen.

Royal Tomb PG 779

During the sixth excavation season at Ur there were many astonishing discoveries but even compared to the many golden treasures the Standard was the most significant find. The cemetery area was excavated between 17 October 1927 and 7 January 1928 and five Royal Tombs were discovered. These included the tombs of Queen Puabi (PG 800) and of an unknown king (PG 789), both with death pits containing many bodies and large quantities of elaborate jewellery and objects. The tomb numbered PG 779, which was the last to be excavated that season, was one of the largest Royal Tombs found at Ur but unfortunately it had been thoroughly robbed in antiquity. It was located at the bottom of a rectangular shaft measuring 12 metres by 8.5 metres,

dug 11.5 metres down through the earth
from the level of the modern ground
surface. The tomb filled the entire area of
the bottom of the shaft (fig. 4). An access
passageway at the north-west consisted
of four steps and a sloping ramp about
1.5 m wide leading down to the main door
of the tomb. Ten copper-alloy spearheads
were found on this ramp, together with
some badly preserved bones that Woolley
estimated could have been the remains
of five soldiers or guards. The tomb was
constructed with irregular blocks of white
limestone and contained four chambers –
two rectangular chambers (A and D) and
two smaller square chambers (B and C).
The interior of the walls and the floors
had been lined with a smooth gypsum
plaster. The roofs of the chambers had
fallen in, but enough was preserved for
Woolley to understand their construction;
the rectangular chambers had arched
roofs topped with capstones, while the two
smaller square chambers had domed roofs.

The objects that were discovered in
PG 779 provide only a very small glimpse
of the richness of its original contents.

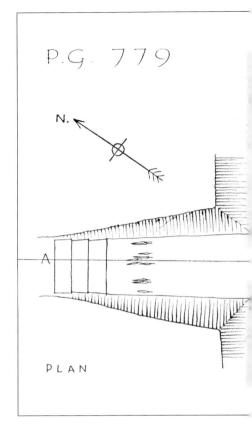

Beads and small items of gold and silver jewellery had been
dispersed throughout the chambers by the tomb robbers.
Chambers A and C each contained a rectangular pit in the
floor with four smaller holes at the corners. Apart from some
beads, these pits were empty but Woolley surmised that the
holes had been for the wooden posts of a bier or platform
supporting a coffin. In one corner of chamber C there
were a few objects that were probably in their original
positions, including vessels of stone and copper, a fluted
silver cup and a gold container decorated with inlays of
shell and lapis lazuli.

4. Plan of PG 779 showing the steps and sloping ramp leading down to the tomb with four chambers.

In chamber D, among the scanty fragments of several human skeletons, were earrings, a small gold cup, a copper-alloy adze (a tool generally used for woodworking) and part of a silver game board with engraved shell inlays. It was broken and had been so disturbed by the tomb robbers that some of the pieces belonging to it were also found in chamber C. Near the south-west corner of the tomb chamber the flattened remains of a human skull covered with thousands of tiny lapis lazuli beads were revealed. In his notes Woolley concluded that these beads had been sewn onto a cap or headdress, but he did not expect to find anything else:

The whole tomb had been cleared except for this corner, where there seemed small probability of anything being found, for the south corner and the south-east generally had produced nothing at all. The discovery of the bead 'head-dress' put the workmen on their guard and involved special care; then amongst the beads appeared a few minute squares and triangles of shell and lapis lazuli mosaic, after them two or three figures silhouetted in shell.

These were shell and lapis lazuli pieces from the Standard. It lay near the top of the skull in the very corner of the chamber. It was the last day of work in the cemetery in early January 1928 but excavating the Standard was to prove to be a challenging, time-consuming task (see p. 47).

5. A page of Woolley's field notes for PG 779 showing the findspot of the Standard (find number U.11164) within chamber D.

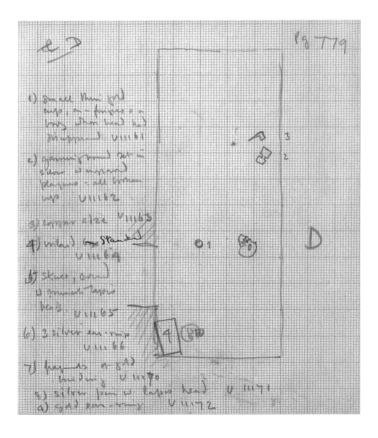

Imagery and meaning

From the time of its excavation the two rectangular panels of the Standard have often been described as 'War' and 'Peace'. This is rather misleading and implies that they show contrasting or opposing scenes. The Standard is an example of narrative art, which means that the pictures illustrate a story or a sequence of events. It is almost certain that what is shown on the two panels are consecutive episodes of the same story. The main event of the story, a war or battle, has just finished and the Standard illustrates what happens next. The narrative is revealed to us by illustrations arranged in parallel horizontal bands, referred to as registers. The use of narrative registers in Mesopotamian art began at least as early as 3300 BC and continued throughout ancient Mesopotamian history. Magnificent examples of this technique can be seen on the carved stone wall reliefs of the Assyrian kings who ruled Mesopotamia during the ninth to seventh centuries BC. The majority of the population of Mesopotamia, including most kings, did not learn to read and write and illustrations were therefore designed to communicate a clear message to the viewer. The symbols or conventions used by the Mesopotamian artists would have been more easily understood at the time than they are today. However, even if the meaning of some of the details are now obscure or open to different interpretations, the Standard is a highly informative work of art. It helps us to better understand other objects found in the Royal Tombs and it also illustrates some aspects of life in Sumer for which there is so far no other surviving archaeological evidence.

The battle scene

The Sumerian artist may have intended some of the action shown on the battle scene panel to be understood as occurring simultaneously. However, from the direction of movement indicated by the figures, it seems logical to read the narrative starting from the left corner of the bottom register and moving up to the top. Many of the people illustrated on the Standard are depicted with their heads

6. (overleaf)
The battle scene.

13

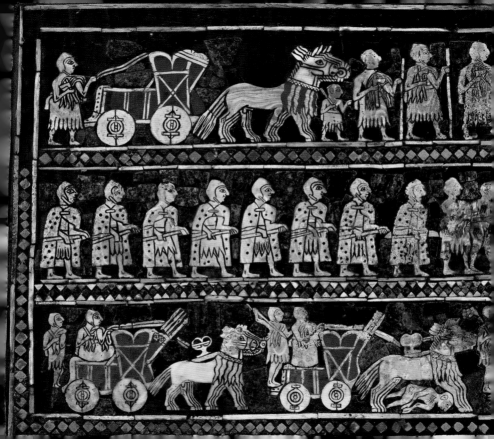

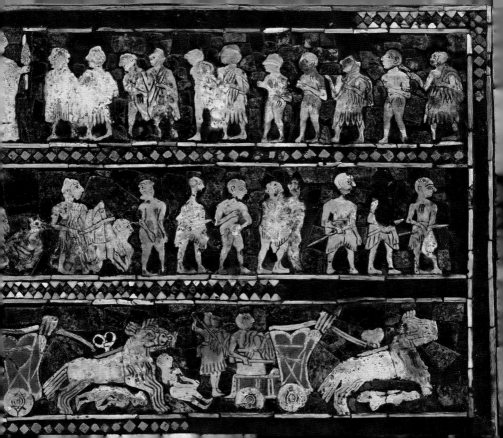

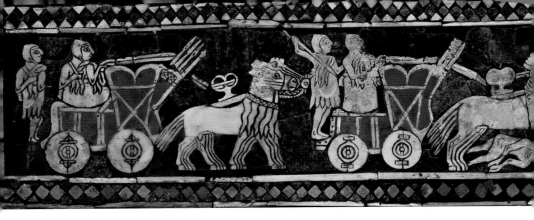

7. The Sumerian battle-cars, carrying soldiers and weapons, are pulled by teams of four asses (detail, bottom register of the Standard).

and feet in profile but their bodies are shown frontally. This twisted perspective is typical of Mesopotamian art and is very helpful as it enables us to see what people were wearing and what they were doing in greater detail than in reality if viewed from the side. Organic materials, particularly textiles and wood, eventually disintegrate when buried in the soil of Iraq so the details shown on the Standard are especially important since they reveal information about items that do not survive.

At the bottom of the panel are illustrations of one of the earliest known types of war chariot. These ancient four-wheeled vehicles, sometimes referred to as 'battle-cars', are also pictured in twisted perspective with their front ends turned towards us. The details drawn on the wheels indicate that they were a solid type made by joining three sections of wood together. The wooden framework of the chariots is illustrated and their red colour probably indicates that they were covered with leather. Quivers containing javelins are attached to the high protective front, the sides are lower and there is a seat for the driver. It is likely that the small, incised dots shown at the back of three of the chariots are meant to represent leopard skin. Part of a stone wall plaque from Ur of a slightly earlier date illustrates a two-wheeled chariot and shows a leopard skin draped over the back (fig. 8).

Each of the four chariots on the Standard is being pulled by a team of four male asses or donkeys. The teams are cleverly indicated by the number of incised outlines

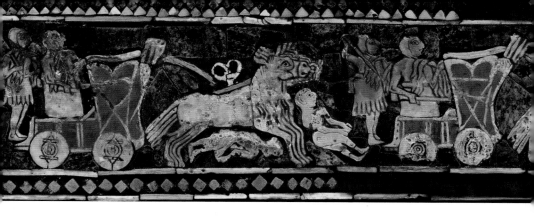

8. Part of the bottom of a limestone wall plaque carved in relief of a type with three registers, showing a banquet scene at the top. c.2650–2550 BC. H. 13cm; W. 27 cm. University of Pennsylvania Museum of Archaeology and Anthropology CBS 17086.

of tails, legs, heads and ears. The donkeys wear muzzles or nosebands and fringed collars; they are controlled by reins that run from their nose-rings to the chariot driver. The reins are also threaded through double rein-rings or terrets that are shown at a disproportionately large size which implies that they had some special significance. Rein-rings of this type, made of different metals, were found in four of the Royal Tombs. One of them is decorated with a donkey or ass similar to those shown with the chariots on the Standard (fig. 9). Each chariot transports two soldiers who have different roles but are dressed alike. They have helmets on their heads

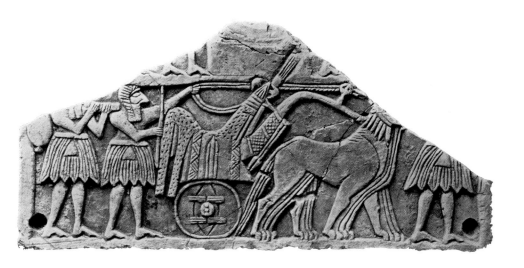

9. Silver rein-ring decorated with a donkey or ass made of electrum (an alloy of gold and silver). From Queen Puabi's tomb (PG 800). H. 13.5 cm; W. 10 cm. British Museum 121348.

and wear material wrapped around their waists like a skirt. It has a fringe or tufts of wool at the bottom and is tied at the back. Either the same material extended up and over the shoulder, or a separate piece was worn. Strips of material, probably a sheepskin, leather or animal pelt, are shown hanging down on both sides of the left shoulder. One soldier drives the chariot while the other holds onto the driver in order to balance on a platform or step at the back, while wielding a javelin or an axe. A variety of weapons dating to the Early Dynastic period (c.2600–2300 BC) have been discovered, and we know that bows and arrows were also used in warfare. However, axes and javelins or long spears are the weapons most often depicted in the art known from this time.

Many weapons were found in the Royal Cemetery, in the graves of men and with the bodies of soldiers or guards within the royal death pits. Most of the heads of the weapons are copper alloy but some decorative weapons buried in the Royal Tombs were made of gold or silver and would have been ceremonial rather than practical (fig. 10). Woolley discovered axes like those being carried by soldiers on the Standard, and several sets of javelins in groups of four, the same number shown in each of the chariot's quivers. One javelin in each of the quivers shown on the Standard is facing downwards displaying the throwing end, rather than the head. Javelins shown facing both ways in chariots can also be seen in other images, including the stone plaque from Ur (fig. 8).

Two of the chariot drivers on the Standard may also have been holding weapons – the driver in the bottom left corner of the panel was probably carrying an axe above his shoulder. The next one along appears to be grasping the reins with both hands. It is not clear what the third driver was holding, but the fourth may be using a forked goad to prod the donkeys. The different

10. Gold javelin (wooden shaft restored) with gold and silver binding, and a forked end probably designed to facilitate throwing using a loop of leather. This is from a set of four found in PG 789. L. 92.5 cm. British Museum 121410.

(below) Copper-alloy axe originally with a wooden handle (restored) thickened at the base like an animal's hoof, painted red and decorated with gold binding. L. 47 cm. British Museum 120689.

19

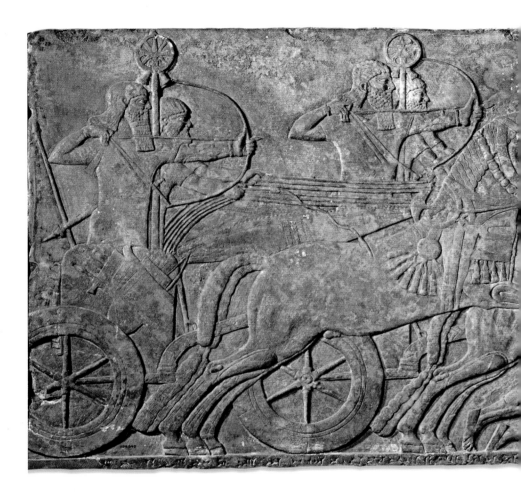

11. Gypsum wall panel (detail) showing a battle scene dating to the reign of King Ashurnasirpal II (883–859 BC). From Nimrud, north Iraq. H. 96.52 cm. British Museum 124542.

actions of the drivers could be related to the evidently increasing speed of the chariots as they move from left to right. It is very clear from the position of their legs that the donkeys at the bottom left corner are walking (and the chariot driver is sitting down), while the other teams appear to be moving progressively faster as they gallop over the bodies of naked, bleeding men. The nude men are either dead or dying on the battlefield. They are shown bleeding from cuts to their chests and thighs and their arms are extended lifelessly in front of them. This is an excellent early example of an illustrative technique used by Mesopotamian

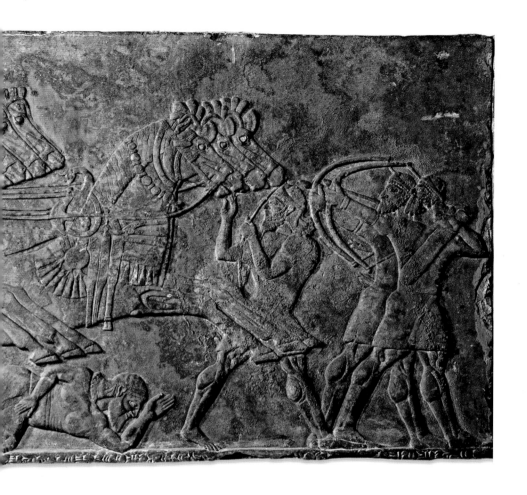

artists for more than 2000 years to convey the humiliation
and defeat inflicted on their enemies during warfare.
Conquered men were shown stripped of their clothes and/
or trampled underfoot by animals, or occasionally by a king
or soldiers.

A cylinder seal found in one of the Royal Tombs shows a
condensed, miniature version of the battle scene shown on
the Standard and even this tiny version includes trampled
and nude captives (fig. 12). Small cylinders, usually of stone,
were carved with a design in reverse so when rolled onto
clay the design was imprinted in relief. They were rolled

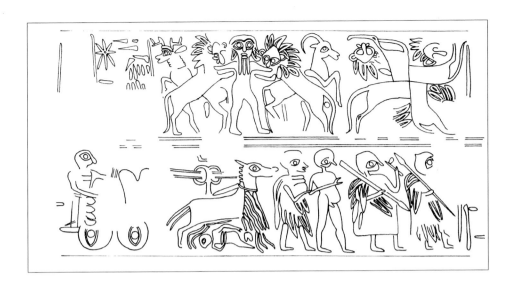

12. A battle scene is shown in the lower register of a limestone cylinder seal (partly damaged) from Royal Tomb PG 1236; a drawing of the scene is pictured here. Drawing by D. Collon. H. (of seal) 4.5 cm; diam. 2.7 cm. British Museum 122538.

over cuneiform tablets and lumps of clay securing doors and containers in order to identify ownership, protect goods from theft and confirm transactions.

In the middle register of the Standard, we see the prisoners of war – the enemy soldiers who have survived the battle but have been captured by the Sumerians and are powerless. As in the bottom register, most of the figures are drawn in poses that indicate a direction of movement from left to right. At the left there are eight soldiers representing the Sumerian infantry who appear to be marching forward in a precise, orderly formation. They are holding spears (the head of each soldier's spear is outlined on the cloak of the man in front of him), and it is even apparent from the details of their hands, that they hold them with their right hands over the shaft and their left hands under it (fig. 13).

They are all dressed in an identical uniform but with slight variations, particularly in the design of the fringes of their skirts. Over these they wear a long cloak or cape fastened at the front below their neck. The incised circles on the capes may indicate decoration or leopard skin, but since battle dress should be protective, the capes may have been studded with metal discs. The helmets worn by all of the Sumerian

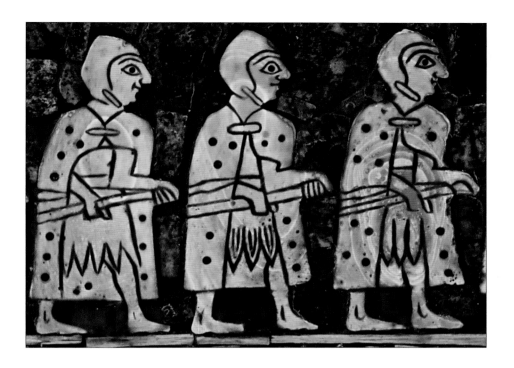

13. No two figures on the Standard are the same. The infantry soldiers all have slightly differing facial features and dress (detail, middle register).

soldiers on the Standard look very similar to the copper-alloy helmets found on the heads of six soldiers lying on the access ramp of the king's tomb (PG 789) (fig. 14). They were crushed flat and their shape was distorted but radiography of one of the helmets has revealed the two cheek-pieces; one had moved across the forehead and the other is hidden under the skull. The small holes through the metal that can be seen in the X-Ray (fig. 15) are for attaching a lining and chin-strap. One aspect of attire shared by all the men shown on the Standard is that they are barefoot. Sandals are mentioned in some Sumerian texts but until about 2200 BC it seems that the people of southern Mesopotamia were illustrated without footwear. However, even in much later Assyrian art when boots are shown worn in battles, some of the military, particularly the archers, were still depicted barefoot.

Ahead of the regimented soldiers on the Standard, other less orderly Sumerian soldiers, dressed in the same way as

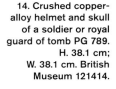

those in the chariots, are rounding up and escorting the captured enemy. Some of the inlays are incomplete or unclear due to the decay of the shell, but we can still see a remarkable amount of detail. The captives are all illustrated in different states of disgrace. They are injured and bleeding from wounds to the chest, legs, head or face and they are being led towards the largest man in the centre of the top register (fig. 16). His size indicates that he is the most important person in the scene and is no doubt a ruler, probably a king of Ur. This technique of 'hierarchical proportion' by which an artist alters the scale of a person to indicate their relative importance, was often used in Mesopotamian art.

14. Crushed copper-alloy helmet and skull of a soldier or royal guard of tomb PG 789. H. 38.1 cm; W. 38.1 cm. British Museum 121414.

15. This X-ray image shows that the helmet is the same type as those shown on the Standard, but during burial one cheek-piece moved over the soldier's forehead.

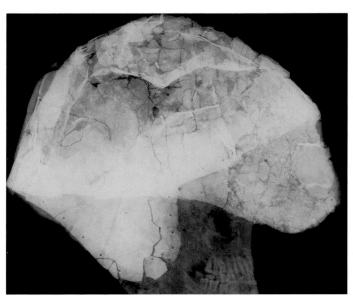

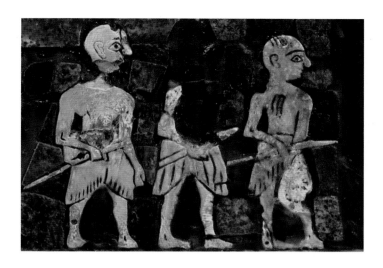

Unlike most Mesopotamian war art, on the Standard the enemy is not shown being killed, nor is there a collection or heap of the conquered dead. In the centre of the middle register, a Sumerian soldier is standing over a captive and may be striking him or, as the soldier ahead of him is doing, he may be about to remove the captive's clothes. Another captive, already naked, is turning his head back to watch this happen. Other prisoners of war shown in the top register are also naked and are being taken to the king with ropes tied around their arms and their necks. Within this procession of the captured and wounded men, at the right end of the middle register, there are some intriguing figures. A few men are pictured carrying spears and wearing a different type of skirt with the material overlapping at the front. It could be suggested that these are men of a different military rank or, because different ethnic groups were usually distinguished by their clothing in Mesopotamian art, perhaps they are not from the city of Ur or they are not Sumerians but they were fighting on the same side. However, at least two of them are bleeding from wounds and if these men are allies, this would be an extremely rare example of the victors shown wounded in Mesopotamian art. Another possibility is that these are soldiers of the conquered army but they have not yet been stripped of their clothes or weapons.

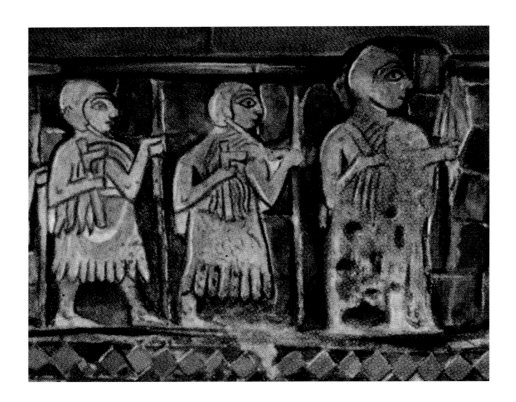

17. The king in battle
dress. Detail from a
watercolour painted by
M. Louise Baker, based
on a photograph of
the Standard as it was
restored in 1929 (see
fig. 39).

In the centre of the top register there are two Sumerian soldiers at the head of the procession of captives. As they face their king, we are given the impression by the artist that the action stops; that the king and all the figures in the left half of the register are standing rather than moving. Although we don't know who this king on the Standard is, we can see that he is the commander of the army. Unfortunately most of the surface of the shell piece he is engraved on is missing, but the few remaining incised lines reveal that he is dressed for battle (fig. 17). He is wearing a helmet and a garment that might be a longer version of the one worn by the soldiers, with material hanging down over his left shoulder. He was originally holding a weapon in his right hand that extended above his right shoulder. In his left hand, there is part of what looks like a large ceremonial spear that he is holding out in front of him. The soldiers

standing behind or to the left of the king are no doubt very important. They could be his elite bodyguard or members of his family and they are also each holding two weapons – an axe and a long spear. One very small figure is illustrated without a helmet or battle dress. It is possible that he is the king's young son or a groom responsible for the donkeys of the king's chariot. The king's chariot, in the top left corner of the Standard, is pictured as a larger version of those shown in the bottom register. The driver is not in the chariot but he is standing next to it and waiting while the bound captives are presented to the king.

The banquet scene

The term 'banquet scene' is used today to refer to illustrations of drinking and feasting in Mesopotamian art. From about 3000 BC onwards this theme was depicted in different ways on many types of objects. From cuneiform texts we know that a wide variety of events were commemorated by banquets in Mesopotamia, including annual agricultural festivals, royal construction projects, legal transactions, marriages and deaths. Religious rituals were an integral part of all such occasions and banquet scenes are therefore associated with belief and ritual. Often there is no inscription with the illustrations, which means that it can be difficult to fully understand the significance of such scenes today.

Banquets were an especially popular theme engraved on the cylinder seals of the Early Dynastic period. Several cylinder seals with banquet scenes were discovered in the tomb of Queen Puabi. One that was found next to her right arm displays banquets in two registers. In the top register the words *Pu-abi* and *nin* 'queen' are inscribed in cuneiform and a seated woman that may be Puabi, is shown holding a cup and facing a seated man while surrounded by attendants (fig. 19). In the Mesopotamian art discovered so far, the ritual drinking scenes depicted most consistently are those that occurred after royal military or hunting achievements. The banquet pictured on the Standard (fig. 18) is almost certainly part of this tradition and represents the celebration of the military victory shown on the other side.

18. (overleaf) The banquet scene.

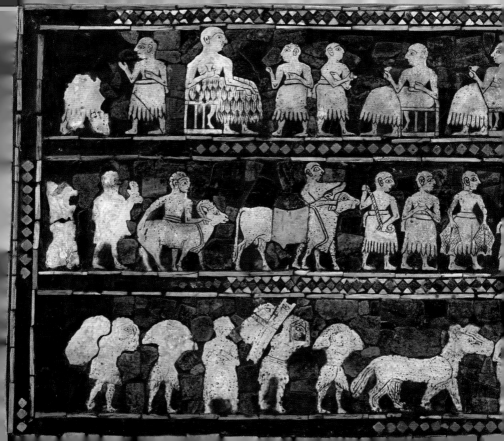

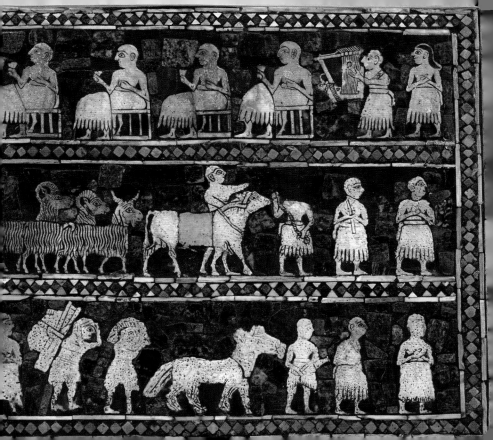

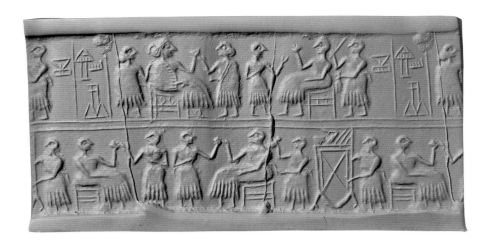

19. (above) Lapis lazuli cylinder seal of Queen Puabi (and modern impression) illustrating two banquet scenes. H. 4.9 cm; diam. 2.6 cm. British Museum 121544.

The postures of the figures in the banquet scene again indicate a direction of movement from left to right in the lower two registers and towards the top register where the most important event, the banquet, takes place. The men in the middle and bottom registers are evidently part of one long procession, bringing animals and goods towards the banquet. At the head of the procession, at the right end of the middle register, and at regular intervals along it, there are five men with their hands clasped together in front of them. This gesture of placing one hand over the other is sometimes interpreted as indicating prayer. Stone statues of the Early Dynastic period and later were placed in temples in Mesopotamia and show people including kings, with their hands clasped like this. The people of ancient Mesopotamia believed that mankind was created to serve the gods and these votive statues (fig. 20) represented the donors' devotion to the god or goddess of the temple. This hand gesture was no doubt one of great respect that suggested a willingness to worship and serve the deity. On the Standard it is probably related to the religious aspect of the banquet and could also be relevant to serving or providing for the king.

In the middle register two bulls are each being led by two men; one man in front of the bull is pulling a rope attached

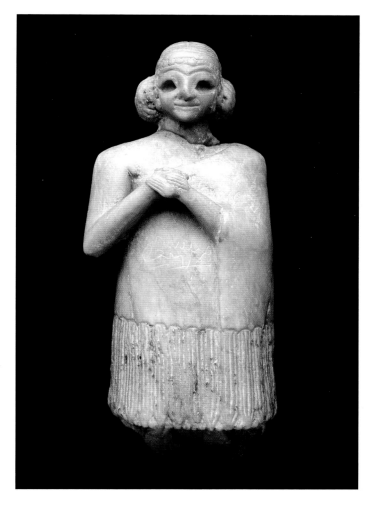

to the bull's nose-ring, while the second man is grasping its horns. The mid section of each bull is made of a piece of red limestone, possibly indicating the colour of the bulls in reality. Between them, a goat herder is walking behind three goats and driving them forward. One of the goats has upright, twisted horns and is probably a markhor goat, originally native to the mountainous regions of Afghanistan and other parts of Central Asia. Behind the goat herder there is a man carrying four large fish. The men bringing

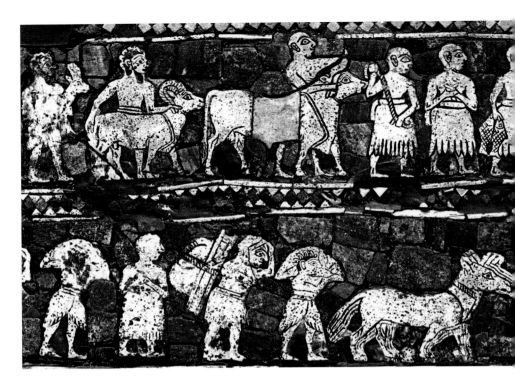

the bulls, goats and fish are all bald, clean-shaven and wearing the typically Sumerian fringed skirt tied at the back. In contrast, almost all of the men following behind them are distinguished by their 'foreign' appearance.

At the left end of the middle register a man is holding onto a ram and another is carrying a goat or gazelle in his arms. Judging from the details we can see, these men both appear to be wearing a non-Sumerian style of skirt and have beards and curly hair (fig. 21). In the bottom register two men are each leading four donkeys by ropes from the donkeys' nose-rings, while six men are carrying goods. Three of these men are holding something that looks like a sack on their shoulders, while the other three have a large backpack consisting of a bundle tied to planks or a frame and attached to a tumpline – a carrying head-strap.

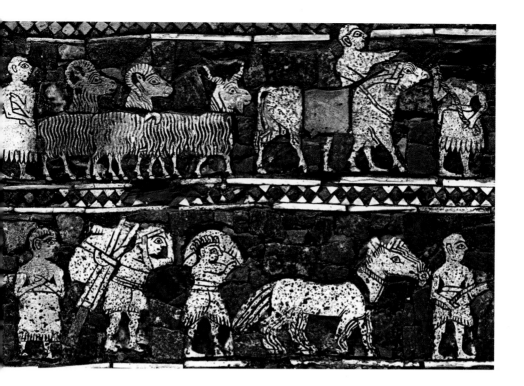

The men leading the donkeys are wearing a style of skirt that overlaps at the front and they are bald. The men carrying the sacks on their shoulders also have this same type of skirt and their hair has upright curls or twists or possibly they are wearing caps with feathers (fig. 22). The porters with backpacks may have a slightly different skirt and their hair is partly hidden by the head-straps. The men with clasped hands also have the upstanding hairstyle or feather caps. There is only one man in the bottom register (second from the right) that has the same appearance and clothing as the Sumerians pictured on the Standard. Like the man directly above him in the middle register, he was originally holding something that unfortunately is now missing, so their role is not apparent.

The artist has surely illustrated these differences of appearance and clothing for a reason. At least some of the Sumerians shown in the middle register are bringing food

to be eaten at the banquet, including animals that will be killed during a ritual. The foreigners might be from different parts of Mesopotamia bringing animals for the banquet and also tribute or gifts to be presented to the king. Men wearing similar skirts are also known on other objects from Ur (fig. 23). The teams of donkeys would certainly have been highly prized, and not intended to be sacrificed or eaten, and the backpacks being carried might include furniture, which was also considered a valuable gift. On the other hand, it may be significant that these men have similar skirts to those shown wounded in the battle scene. It is possible that they are the conquered people bringing the booty or spoils of war to the king. The teams of donkeys could be from the enemy chariots and the goods being carried might represent plunder. It was an enduring tradition in

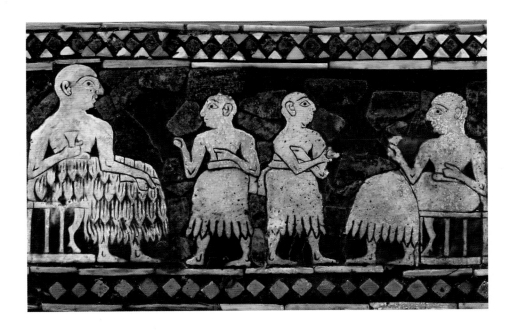

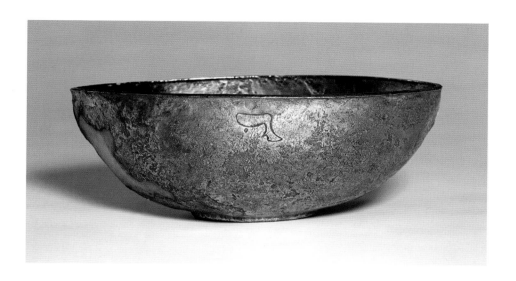

Mesopotamia that after a battle the cities of conquered enemies would be plundered. Everything moveable was seized – objects, furniture, animals and people and all would be paraded in front of the king. The most extensive illustrations of victorious kings receiving people, animals and goods after a battle can be seen on Assyrian palace wall reliefs of the ninth to seventh centuries BC, but this tradition had already been established by the time the Standard was made.

Near the left end of the top register, the king is shown sitting and facing the other participants at the banquet (fig. 24). He is again depicted at a larger scale than everyone else and he is also distinguished by his more elaborate flounced skirt. He is holding something in his left hand that is now partly missing, but in this context we would not expect to see a weapon. Several other contemporary banquet scenes illustrated on stone plaques show the seated king holding the male flower spathe of the date palm, an emblem of agricultural fertility. The king and all the banqueters are sitting on a chair or stool that has three plain legs and one that is animal-shaped, probably a bull's leg. The bull's leg must have had special significance for the elite of Ur because it was a symbol engraved on various weapons and vessels

found in the Royal Tombs (fig. 25). Bulls' legs can also be seen supporting the table shown in the lower register of Puabi's cylinder seal (see fig. 19). Mesopotamian furniture rarely survives burial, but from later artworks we know that furniture supported by bulls' and lions' legs or decorated with animal motifs, continued to be made for Mesopotamian kings for thousands of years.

Six seated men are shown in a line facing the king; in reality of course, they would be more likely to sit in a semi-circle around him. No doubt these are important men who may also have been involved in the battle and/ or are members of his family. Three small (and therefore unimportant) male attendants are shown standing and probably offering cups or drink to the banqueters. One of them has his left hand tucked under his right armpit which may be a polite way to offer a service (see fig. 24). The attendant behind the king (see p. 28) is addressing a figure that is now mostly missing but was facing the same direction as the king and was relatively large, possibly a queen. The king and the seated men are all holding a cup out in front of them. Drinking was the most essential aspect of any Mesopotamian ritual celebration. In smaller artworks even one seated figure holding a cup could indicate ritual drinking, and some votive statues placed in the presence of a temple deity, depict a person with a cup instead of clasped hands. In the banquet scenes of the Early Dynastic period people are shown drinking from large jars through long straw-like tubes, or holding cups. The tubes were necessary to filter out the sediment in beer while the cups probably contained wine. Even in the poorest graves of the Royal Cemetery, the dead were buried with a ceramic drinking cup. Hundreds of cups and tumblers were found in the Royal Tombs, including stacks of silver drinking cups of the type being used in the ceremony shown on the Standard (fig. 26). From inscriptions and the art of later periods we know that the ceremonies that followed battles included ritual libation pouring (drink poured in honour of a deity) and dedications to a god or goddess. Kings won battles on behalf of the gods and only with their assistance; therefore, after the battle the gods must be thanked.

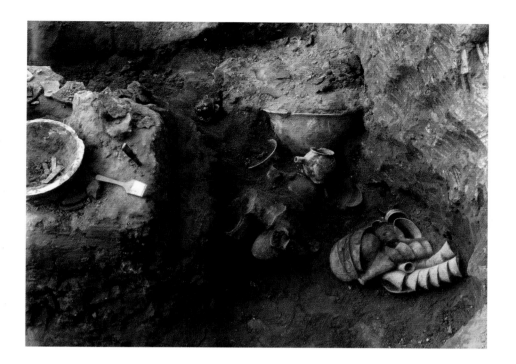

26. A stack of silver drinking cups and bowls discovered during the excavation of Queen Puabi's tomb (PG 800).

Another very important aspect of victory celebrations and rituals was music. In the top right corner of the banquet scene, a musician is playing a bull-shaped lyre carried by a shoulder strap (fig. 27). Lyres with bulls' heads were buried in several of the Royal Tombs with female musicians who were probably playing music at the royal funeral ceremonies, just before they died. The wooden parts of the instruments had decayed, but Woolley poured plaster into the holes in the ground left by the vanished wood and so preserved their shapes and inlaid decoration. They are decorated with strips of lapis lazuli, shell and red limestone mosaic and with front panels of incised shell inlays arranged in registers. The front of the lyre found in Queen Puabi's tomb (fig. 28) is covered with images of animals illustrating the popular Mesopotamian theme of 'contests' – combat between men and wild animals or between domesticated and wild animals.

Next to the lyre player on the Standard there is a singer with long hair, standing with clasped hands. Despite the long

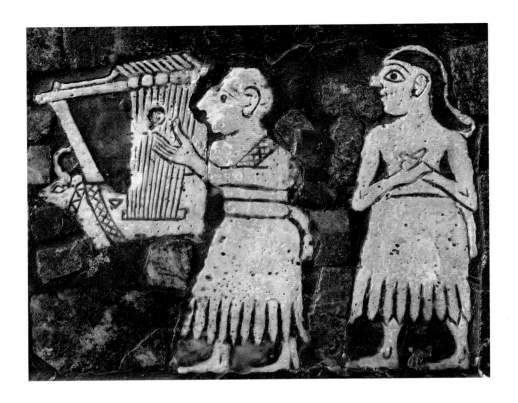

27. (above) Two musicians – one plays a bull-shaped portable lyre while the other sings (detail, top register).

28. (opposite) The 'Queen's Lyre' has a bull's head of gold, lapis lazuli and shell. H. 112.5 cm; L. 95.5 cm. British Museum 121198.a.

hair, the singer is not female and is wearing the male skirt rather than a woman's garment covering the chest (for example, as is shown by the votive statue in fig. 20). It seems that it was not unusual for male musicians to have long hair at this time. A contemporary votive statue found at the ancient site of Mari in present-day Syria, portrays a very similar long-haired man named in an inscription as 'Ur-Nanshe the master musician'. Other banquet scenes on stone plaques also show long-haired male harp players. There is evidence that a wide variety of musical instruments were played in Mesopotamia, and some cuneiform texts from later periods even reveal information about tuning and playing instruments. However, it is not possible to know what was music to the ears of the Sumerians.

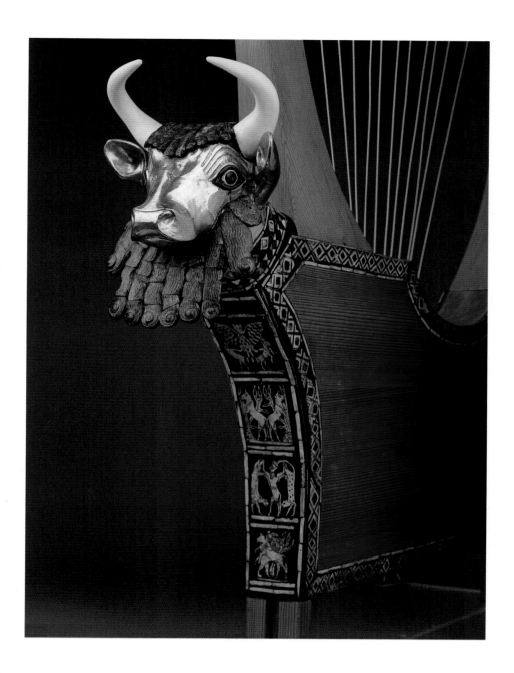

Does the Standard show a real event?

The scenes on the two rectangular panels of the Standard are the most complete examples of Sumerian narrative art to have been discovered. They illustrate the aftermath of a battle with a banquet more thoroughly than any other object of the time. Currently we cannot match the illustrations on the Standard to a particular king or to a war that was won by a king of Ur. There is a small chance that in the future, further archaeological discovery may make this possible if a written description fitting the scenes on the Standard was to be found. Contemporary and later scenes of warfare that have inscriptions on them do appear to relate to real battles. However, much of the surviving art of ancient Mesopotamia was created with the purpose of glorifying the king and reinforcing his relationship to his people and the gods. Kings were consistently featured in certain types of scenes that picture them carrying out the duties expected of good Mesopotamian rulers. These duties included being a warrior or protector of their people and a provider. In addition, as the representative of the gods on earth, the king was expected to perform rituals to ensure the gods' continued support. On the Standard the spotlight is focussed on the king and it serves a purpose of illustrating these aspects of ideal kingship and, because it was buried in a tomb, it could have been made to commemorate the successes of a king in general rather than recalling one specific military victory.

The end panels

After its discovery, one of the end panels of the Standard was partly reconstructed while the other end was completely created from scattered inlay pieces (see pp. 52–53). It is therefore possible that a few of the pieces don't belong at the ends of the Standard. Since then the positions of the inlays, most of which were uncertain to begin with, have been completely changed. Neither arrangement is likely to reflect the original intention of the Sumerian artist, but the end panels do show some important Mesopotamian imagery.

One image that was especially significant in Sumer during the Early Dynastic period was a goat rearing up against a tree or plant as if to reach tasty leaves to eat. This motif of

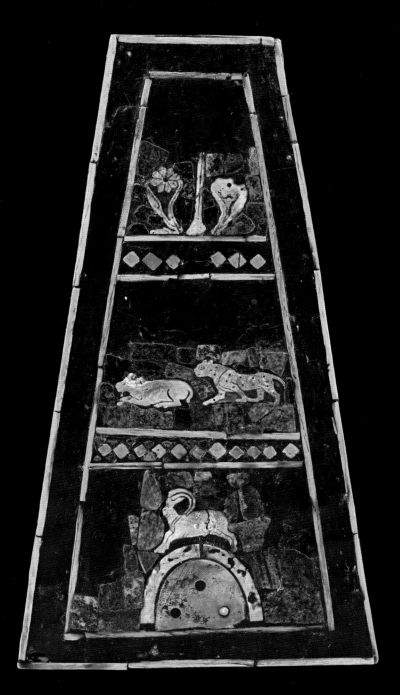

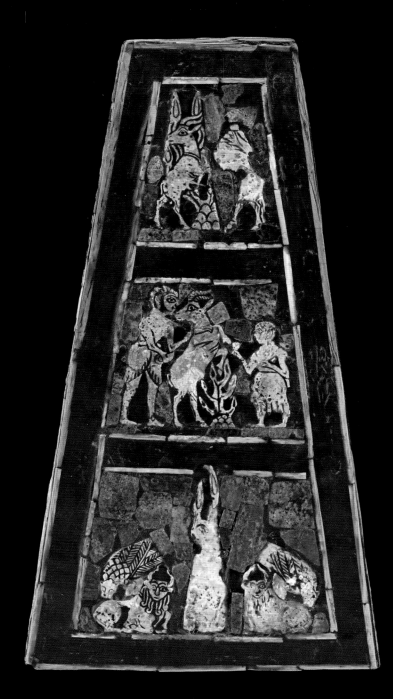

30. (opposite) End panel B.2.

animal and plant life symbolises nature and fertility, both of which were of crucial importance to human life in Sumer. The goats were usually depicted in pairs either with a tree between them, or back-to-back and each facing a tree (fig. 31). There are parts of several goat and tree images on end panel B of the Standard (fig. 30). One can clearly be seen in the top register but two others in the top and bottom registers are unclear or incomplete. There is also some decayed shell at the left end of the middle register of the banquet scene that might be part of a goat. The trees are often pictured above small domes that represent hills or mountains and they have leaf-like buds or large leaves and flowers. Stylised flowers or rosettes were a symbol associated with the Sumerian goddess Inanna (Akkadian Ishtar) and they appear in many different contexts in Mesopotamian art. It is probable that the two flowers at the top of the other end panel (fig. 29), originally belonged with trees. The most famous examples of the goat and tree motif are a pair of

31. (below) Shell inlay of two goats eating leaves from a plant or tree. From Queen Puabi's tomb. H. 4.4 cm; W. 4.4 cm. British Museum 121529.

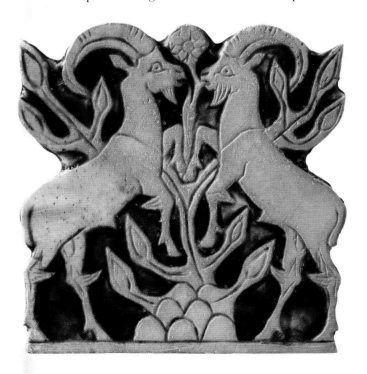

sculptures found together in the Great Death Pit. One of these can be seen in the British Museum (122200) and is known as the 'Ram in a Thicket' because this reminded Woolley of the Biblical story of Abraham who was asked by God to sacrifice his son Isaac. As he was preparing to do so he saw a ram caught in a thicket. Occasionally other animals are substituted for the goats. For example, on the Queen's Lyre (fig. 28) two rearing bulls are shown with trees.

In the middle register of end panel B (fig. 30), there is a man who appears to be attacking a goat rearing up against a small tree. This man has the same hairstyle and type of clothing as the 'foreigners' in the banquet scene and he might be either catching or killing the goat. This evidently complements the theme of animals being brought to the banquet or sacrificed. On the other side of the goat there is a Sumerian man holding a cup in the typical pose of an attendant or server in a ritual drinking scene. Although it is highly unlikely that he would originally have been in this position offering a cup to a goat, he is also appropriate to the banquet scene.

In the bottom register of panel B there is a pair of shell inlays showing a lion-headed eagle biting the back of a human-headed bull or bison. The full face of the human-headed bull is shown looking at the viewer which is typical of some deities and mythical human-headed creatures shown in Mesopotamian art. These divine bulls feature on various objects including cylinder seals of the third millennium BC. Sometimes they are pictured being protected by men from the attack of wild animals, including the lion-headed eagle. This monstrous creature, named Imdugud in Sumerian, featured in Mesopotamian myths and was also illustrated with outspread wings and grasping two animals, as shown in the top register on the front of the Queen's Lyre (fig. 28).

How was the Standard made?

Materials

Sumer achieved great economic success through agriculture but lacked natural resources. Almost all of the stones and metals needed for tools, weapons, colourful jewellery and beautiful objects had to be obtained via a long-distance trade network. Most of the materials arrived at Ur in raw form to be transformed into elaborate objects by skilled Sumerian craftsmen. The vibrant, contrasting colours of gold or white with blue and red, consistently used for jewellery and art, evidently had special significance for the Sumerians. The surviving components of the Standard are lapis lazuli, red limestone, shell, bitumen and a red pigment. The composition of the lapis lazuli found at Ur indicates that it comes from the region now known as Badakhshan in Afghanistan and would have arrived in Mesopotamia via trade routes through the Zagros mountains and Iran. Lapis lazuli was a highly valued stone not only because of its beautiful blue colour but also because in Mesopotamia it was believed to have magical or amuletic properties. The shell used for many of the inlay pieces is a large conch shell commonly referred to as the giant spider conch (*Lambis truncata sebae*), the nearest source of which is the Gulf of Oman. Other smaller shells may also have been used for the borders of the Standard. The red pigment, originally in the incised lines of the wounds of the enemy as well as on the chariots, is an iron oxide derived from haematite and probably sourced from Turkey. The origin of the pink-red limestone is uncertain but it may have been obtained from northern Mesopotamia. The most easily acquired material was bitumen. This black, sticky form of petroleum is one of the few naturally occurring resources of Iraq and was often used by Sumerian craftsmen as an adhesive. The current Arabic name of Ur, Tell al-Muqayyar, can be translated as 'mound covered with bitumen' and results from the fact that the bitumen used in the ancient buildings is visible on the surface of the site.

Techniques

It is probable that craftsmen who specialised in working with the different component materials produced different parts of the Standard under the direction of an artist or 'designer'. The panels of the Standard were made by combining two artistic techniques – inlaying and mosaic decoration. Both of these methods were applied in Mesopotamia from at least as early as 3500 BC. During the Early Dynastic period a wide variety of objects, vessels and jewellery were decorated with pieces of shell and colourful stones. The inlaid pieces were either set into hollows within the surface of objects, or they were stuck into a layer of bitumen over wood or metal. At Tell al-'Ubaid near Ur, a temple built around 2500 BC was decorated with panels of copper and wood covered with bitumen and inlaid with shell figures (fig. 33). The background of the shell figures was composed not only of bitumen but also of a mosaic of irregularly shaped pieces of stone or tesserae. This same technique was used for the background of the Standard, where lapis lazuli was cut into different shapes and sizes to fit into the spaces between the shell figures. The borders of the Standard were created with tiny square and triangular tesserae of lapis lazuli, red limestone and shell arranged between strips of shell. On the two rectangular panels these were positioned so that the horizontal borders of

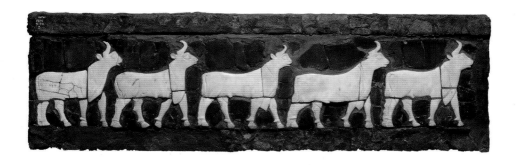

33. Frieze of five shell bulls with a background of black stone and bitumen. From Tell al-'Ubaid. H. 22.2 cm; L. 69.9 cm. British Museum 116741.

the registers display alternating geometric mosaic patterns.

Many of the inlaid shell figures of the Standard are made with one piece of shell but some consist of two pieces – for example, the skirts and feet of the seated men of the banquet scene are a separate piece of shell from their bodies and chairs. Comparison of images of the same type, such as the soldiers with cloaks or the chariots, shows that they are all slightly different shapes and sizes, and not cut around a template. Within the outline of the image, details were incised into the surface of the shell and some areas were carved away to a depth of about 1 mm, leaving the details in relief. Bitumen or red pigment was then applied over the surface to fill in the hollowed-out parts and emphasise the incised details. So, for example, between the legs of the figures and chairs and within the body of the chariots, there is shell but it is covered with colour. The shell can just be seen showing through between the chair legs in fig. 24, and also between the front arm and strings of the lyre (fig. 27). This technique of carving away the background shell, leaving the details in relief, was also used for inlays on many other objects discovered at Ur and can be seen on the goat and tree inlay (fig. 31).

Excavation and preservation

It is remarkable that this object made by people living long ago has survived for us to appreciate today. This is due to a sequence of very fortunate events: it was deliberately buried inside a tomb, missed by tomb robbers and then discovered during an archaeological excavation. The Standard also

owes its survival to the patience, skill and resourcefulness of Leonard Woolley and the continuing care of museum conservators and curators.

The Standard lay buried in the earth for thousands of years so the wood had completely disintegrated by the time it was unearthed by Leonard Woolley. Woolley knew that there had originally been some wood because imprints of wood grain were evident in the remaining traces of the bitumen used to attach the inlays to it. As the wood decayed, the battle scene, which was lying face up, was compressed down onto the back of the banquet scene. In addition to this, some heavy stones fell from the roof of the tomb chamber breaking off parts of both panels and causing distortion and scattering of inlays.

At first Woolley couldn't see what the inlays were illustrating and he didn't know that there was more than one panel, but he did know that it was very important to keep the inlay pieces together in the same arrangement that they lay in the soil. During the excavation of the Royal Cemetery, he developed innovative techniques of using wax to hold parts of objects and skeletons together. Ur excavation photographs show that sometimes a workman would melt paraffin or beeswax in a pan over a wood fire inside the tomb being excavated so that Woolley could have it near at hand (fig. 34). In his publication on the excavation of the Royal Cemetery Woolley described the laborious processes of first exposing and then lifting the remains of the Standard out of the earth:

> *Such was the condition of the mosaic that it was only possible to clear a square inch or so of it at a time, and even then some of the dust had to be left on it, for the minute shell triangles of the border were so light that the most careful brush-work could not help but displace them. As soon as a few tesserae showed, boiling wax was poured over them to hold them in position, and the whole process was repeated until the whole panel was waxed, by which time what with wax and dirt it was completely invisible. Then muslin was waxed down onto the surface, to bind it, and the panel was lifted in one piece. This disclosed the presence of the second panel, lying face downwards.*

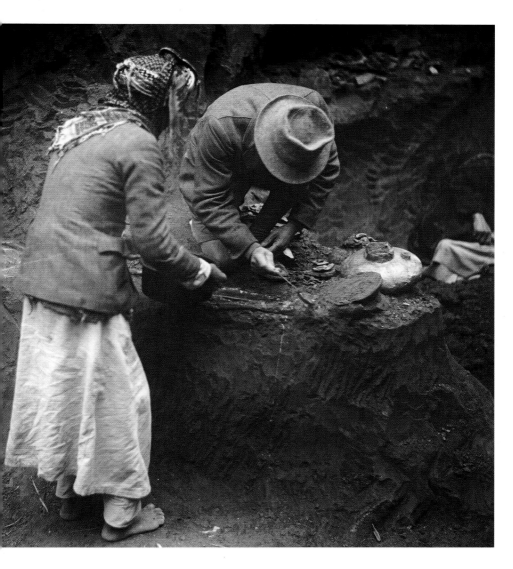

34. A workman holds the pan of wax (heated on the fire behind him) as Woolley excavates a skeleton.

This same procedure was repeated in order to excavate the remains of the banquet scene and then both panels also had wax and cloth applied to their other sides. Part of one of the end panels was found at the left edge of the battle scene and was attached to it by the wax. But according to Woolley the other end panel was 'completely smashed and

35. The pieces of the battle scene, held together by cloth and wax. The remains of the reconstructed end panel A.1 are attached to the lower left corner.

only its scattered fragments could be collected.'
Other inlay fragments were also retrieved separately
from the surrounding soil; a stone had dislodged the shell
figures from the lower right corner of the banquet scene
and some fragments from the edges of the Standard had
also been scattered.

Woolley knew that the Standard was an object of
unique importance even before it was cleaned and could
be properly looked at, and he was keen to oversee its
restoration at the British Museum. It was certainly not
taken for granted that it would be allocated to the British
Museum, but regardless of where they would eventually
be housed, many of the important artefacts from the
Royal Cemetery were sent to London to be repaired.
At that time there were very few museums in the world
with conservation research laboratories. The panels of
the Standard, sandwiched between waxed cloth, arrived
at the British Museum in March 1928 and the initial
reconstruction was carried out in the research laboratory
under Woolley's supervision. He believed that it was very
important to preserve as much of the original work of
the Sumerian artist as possible and that the panels of the
Standard should be renovated without the inlay pieces
being separated.

*Now, it would have been perfectly feasible to take the mosaic
to pieces, bit by bit, and re-make it on a new background,
and the task might have been done as well by the modern
craftsman as by the old, but the panels would have been
the work of a modern craftsman.*

To summarise Woolley's thorough explanation of the
delicate operation – the cloth was removed from the fronts
of the two panels and they were laid face down onto a
sheet of glass. The wax was kept soft by being continually
warmed while the inlay pieces were pressed from behind
onto the surface of the glass. By looking through the
underside of the glass, the inlays and pieces of lapis lazuli
background could be realigned. The two panels were each
given a new backing of cloth and paraffin wax and were
attached onto rectangular pieces of wood. A few of the
inlay pieces that had been dislodged were replaced in the
positions Woolley thought to be the most correct at that
time, judging from where they were found in the earth.
Some gaps still remained; the heads of the four donkeys in
the top register of the battle scene were missing as well as
the weapons in the king's chariot, figures from the left edge
of the banquet scene and pieces from the backgrounds
and borders of both panels. The decay of some of the
shell inlays had resulted in eroded surfaces and small
pieces of shell had completely disintegrated. Some spaces
resulting from missing lapis lazuli tesserae were filled in
with pieces of vulcanite, a manufactured hard rubber.

The shape of the two ends, and consequently the shape
of the three-dimensional reconstruction of the Standard,
was based on the inlay pieces found in the ground at the
left edge of the battle scene and lifted with it in the wax
(fig. 35). To be more specific – the truncated triangular
shape of both end panels was proposed as a result of
the lengths of the strips of shell and the amount of small
tesserae that had survived from the borders below the top
and middle registers of one end of the Standard. This
seems surprising because many tiny inlays were missing
from all of the other borders of the Standard and those

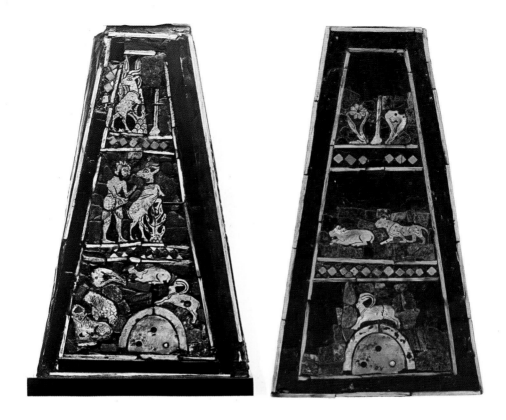

36. A.1 (left), the end panel as restored by Woolley and A.2 (right) as it appears today.

that remained were not a reliable indication of width or shape elsewhere. During the restoration of the end panel the shell inlays were positioned more or less as they were found in the ground (fig. 36, A.1). Therefore, even though Woolley knew that almost certainly there should have been another goat in the top register, an upright piece of shell found in roughly that position in the ground was placed there.

The mosaic background of the right side of the register is simply a patchwork and the shell upright is very likely wrong; it lay about in this position and was lifted in position with the 'War' panel, but everything here was so much broken up that reconstruction is little more than guesswork.

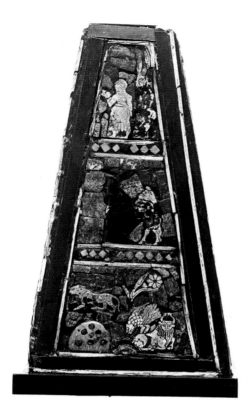

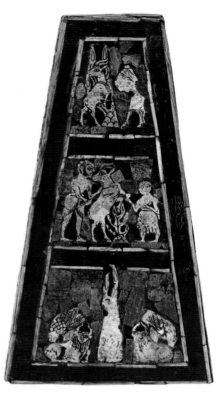

37. B.1 (left), the end panel as reconstructed by Woolley from scattered fragments and B.2 (right) as it appears today.

The second end panel was created with shell inlays that had been found in the soil nearby and Woolley was candid about the fact that this end was entirely reconstructed (fig. 37, B.1). The bottom register was arranged using pieces found to be similar to those on the other end panel but Woolley remarked that 'there is no certainty elsewhere, and the top register is particularly unconvincing'.

The four panels were attached onto a wooden mount and strips of vulcanite were used to recreate borders, while small slivers of wood replaced missing strips of shell edging. For some reason the end panel unearthed at the left edge of the battle scene (fig. 36, A.1) was put at its right end. Perhaps it was thought to be better that the man and goat in the middle register should be facing the middle register of the banquet scene instead of the line of soldiers.

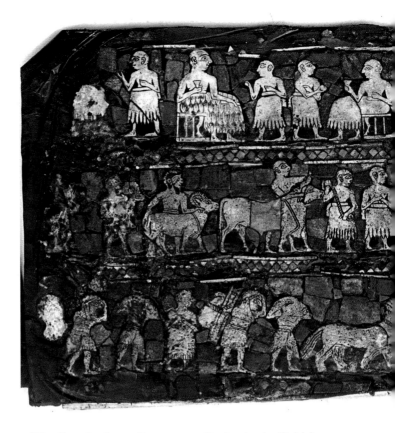

The Standard was first put on display in the British
Museum from June to October 1928 in the sixth
temporary exhibition of objects resulting from the
excavations at Ur. The exhibition drew huge crowds;
there was great public interest in the Standard and
it has been a very popular attraction in the British
Museum ever since. On the 10th October it was officially
registered in the British Museum collection, following
the agreement on the division of the Ur finds of 1926–8
between the Iraq government, the British Museum and
the University of Pennsylvania Museum. The following
year a few small adjustments were made to the Standard.
Miraculously the small piece of shell inlay showing the
donkeys' heads had been found when the excavation

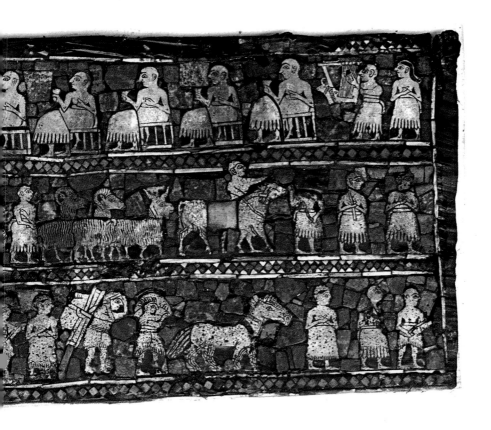

resumed at the end of October. In addition to this piece being reinstated, the three figures in the bottom right corner of the banquet scene were rearranged. The order of their placement on the panel had been based on the distance that they were found from the panel, but this had resulted in the man holding the lead rope being separated from the donkeys.

Unfortunately, because it was mainly held together by wax the Standard was liable to be affected if the temperature increased in the Babylonian Room where it was displayed. During the 1950s and again in 1961 some small repairs had to be undertaken as a result of the wax softening due to summer weather. The Standard also suffered damage as a consequence of its fame and growing

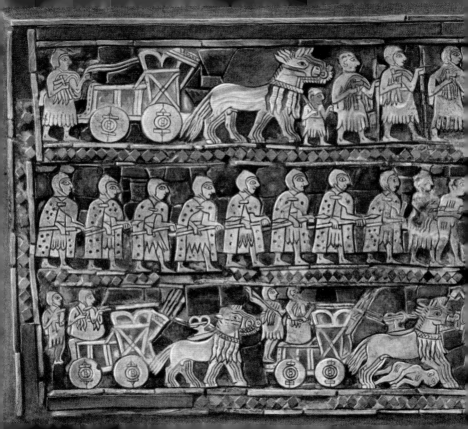